Southern Dogs
&
Their People

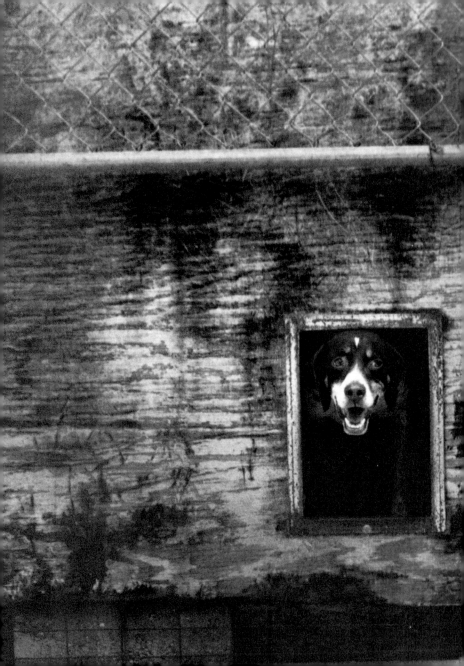

Southern Dogs
&
Their People

■ ■ ■

PHOTOGRAPHS BY
P. S. Davis

EDITED BY
Roberta Gamble

WITH AN INTRODUCTION BY
Clyde Edgerton

Algonquin Books of Chapel Hill 2000

Published by
ALGONQUIN BOOKS OF CHAPEL HILL
Post Office Box 2225
Chapel Hill, North Carolina 27515-2225

a division of
Workman Publishing
708 Broadway
New York, New York 10003

Library of Congress Cataloging-in-Publication Data
Southern dogs and their people / [selected] by
P. S. Davis and Roberta Gamble

 p. cm
 ISBN 1-56512-268-2
 1. Dogs—Literary collections. 2. Dog owners—
Literary collections. 3. Southern States—Literary
collections. 4. American literature—Southern States.
5. Dogs—Pictorial works. I. Davis, P. S. (Priscilla S.),
1941- II. Gamble, Roberta. III. Title.

PS509.D6 S68 2000
636.7'0887'0975—dc21 00-035557

10 9 8 7 6 5 4 3 2 1
First Edition

■ ■ ■

To my grandmother, Frances Beeland Wilkinson,
for the love and encouragement that surrounds me still.
To Judith Frederick, for believing from the beginning.
Her prayers, time, and artistic eye proved invaluable to me.
To Cleveland Brown for introducing me to the camera
and patiently teaching me how to use it.
To Lilo Raymond for inspiring me.
To Ann, Emma, and Duffy Bayer, God's gift to
Central Park South, for never doubting.

—P. S. DAVIS

■ ■ ■

To Bub, Genie, Roger, Ann, Lee, and all the dogs
who have shared our lives . . . and to Duncan.

—ROBERTA GAMBLE

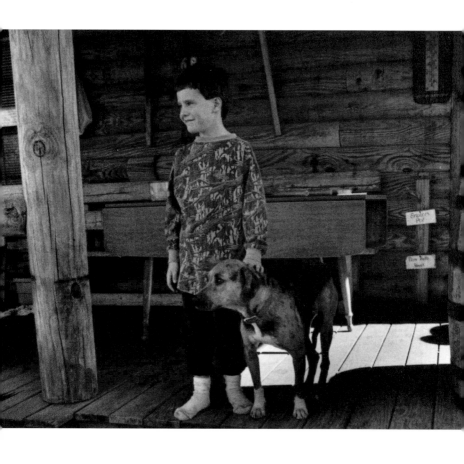

Acknowledgments

■ ■ ■

The authors wish to express their grateful
acknowledgment to the following:

Amelia Gayle Gorgas Library staff of the University of Alabama,
Tuscaloosa, Ann Bayer, Judith Frederick, Arthur E. Gamble, Jr.,
Ben Garrard, Bob Garrard, Greenville-Butler County Library staff,
Greenville High School Library staff, Robin Hall, Huntingdon
College Library staff, Annibel Jenkins, Annabel Noe Markle,
Sarah DeLand Marshall, Burke McFerrin, Duncan Murrell,
Virginia Jenkins Peacock, Sheila Perdue, Jennifer Shell, Bob Thrower,
Cheryl Upchurch, and Emma Darlene Watts.

■ ■ ■

A sober, dark-brown, middle-sized dog named Rowdy, who, though he is most strictly suggestible in his resemblance to André Gide, is nevertheless as intensely of his nation, region, and class as Gudger himself.

—JAMES AGEE

Introduction

■ ■ ■

by CLYDE EDGERTON

I held the water pan—about the size of a shallow bread pan—under the spigot of the water tank that was attached to the side of my Uncle Bob's Jeep truck. Uncle Bob had just told me to draw water for the bird dogs; he knew a boy with men loved to do errands. We were deep in the central Florida woods on a December quail hunt in the late fifties. It was lunchtime and everybody was hot and already tired.

I turned on the spigot and as the water flowed into the pan, Old Joe came over and started lapping. He was plenty thirsty, and the water level in the pan was barely gaining on him.

What I can never forget is the feel of Old Joe's throat pressed against my upturned wrist as he swallowed and lapped and swallowed for what must have been almost a minute. His moving throat seemed to hold secrets and a soul, and for that short while I was almost Dog.

Old Joe was a hero. I was just a boy on a hunt.

Old Joe was Uncle Bob's favorite pointer, and Uncle Bob told more stories about him than he did about any other dog. Among the others: Leaping Lena, Jake, Dan, and Sue. Anybody who has grown up with dogs knows that their personalities are as distinct as those of people. Some are mere soldiers, others are officers, some shun the limelight, some live for it, some are shy, others brash, some have a sense of humor, some don't.

Old Joe was a mix of dignity, strength, and tenderness, with the biggest head and chest of any pointer I've ever known. He didn't have much of a sense of humor, but he was one grand dog, a leader. Jake, a square-headed, medium-sized pointer, had a sense of humor—very dry. He would not look you in the eye and was sometimes a bit awkward. He was not comfortable socially. You could almost feel him quietly observing and thinking, finding ridiculousness in his dog-human world, then laughing to himself. Jake wasn't a steady hunter; he had his bad days and his good days. But Old Joe was always all business, a brilliant strategist. He was a wise dog.

One of my favorite stories about Old Joe, one that Uncle Bob loved to tell, was how Uncle Bob came upon him pointing a covey of quail while standing right at a nest of mad wasps. Joe had clearly upset them just before freezing into his point,

and while he stood there, they were stinging him. So Old Joe would reach back, pick one off with his teeth, bring his head back around to a full point, then pick another off, and so on, never moving his feet. And while Uncle Bob told the story, he would do the teeth part, turning his head, as if he were picking wasps off his back.

BACK IN NORTH CAROLINA, we always had a home dog around the house (Bullet, Dusty, Sargent) as well as pointers. The two pointers my daddy owned when I was born were called Nick and Sam.

Nick was black and white, and Sam was brown and white. Sam was my favorite because he would pay me some attention. Nick wouldn't give me the time of day. When I was very little and realized that they did jobs with grown-ups, I thought of them as beings akin to older men, beings to whom I owed some kind of allegiance. I admired them and hoped to earn their respect.

WHEN I WAS SIXTEEN, my daddy's bird dog, Queen, had a litter of ten, and I was given a dog I named Ben. Daddy kept one he named Duke and we gave the others away. Within a few weeks, all except four were dead from a disease they caught from Queen's milk. Ben lived, Duke didn't.

I spent as much time with Ben hunting quail as I did hunting with any friend. We got to know each other well. He developed almost naturally into a fine bird dog who would do it all—point, retrieve, back, hunt close. We had adventures together and when I left home at age twenty-two to join the Air Force, I left him behind almost like I might leave a brother, if I'd had one. My parents would send me pictures of him along with pictures of other relatives.

My father's emphysema finally kept him from hunting, so Ben took up with a little neighborhood dog, Skip, and together they would explore. Just before I got out of the Air Force—I was twenty-six, and Ben was ten—he and Skip were shot dead in a neighbor's chicken pen. I'd taught him not to chase chickens, but with me gone, he backslid. A bird dog wants birds.

So Ben and I missed the later hunting days that could have led to him being Old Ben.

I did have an opportunity—the winter before he died, when I was on Christmas leave—to take Ben to Florida for several hunts with Uncle Bob and his dogs. Old Joe had passed away a few years earlier, so he was along only in spirit. On one of those last days that I ever hunted with Ben, he found his stride as a master. It was one of only a handful of hunting days I'll always remember. Of the twelve coveys of quail we found

that day, Ben found eight. Up against the well-conditioned, old-timer bird dogs of serious Florida quail hunting, it was as if he'd won a horse race by twenty lengths, scored fifty points at a basketball game, run a hundred-yard return for a touchdown. And Uncle Bob paid him the supreme compliment: "He reminds me a little of Old Joe." And on that day, as on all other hunting days with Uncle Bob since that first time back in the fifties, I drew the water at lunchtime.

I did not grow up in a culture of dog shows. I grew up in a culture of Dog. There is a difference. And this book—of real dog photos and real people words—shows it. Reading along, you might occasionally find a dog throat on your wrist.

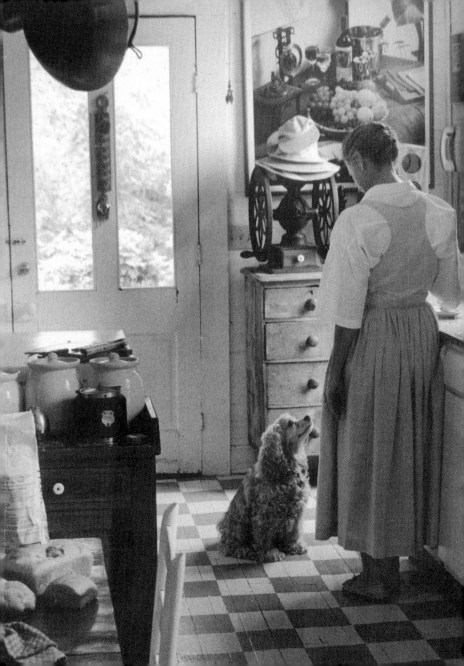

Having no souls, they have come,

Anyway, beyond their knowing.

Their instincts wholly bloom

And they rise.

The soft eyes open.

—*James Dickey*

. . . Sandy had found him in the weeds along the interstate, near the overpass. Lisa said Bob wouldn't go out because he was stupid. She said he'd never learn anything and said they should take him straight to the pound before they got too attached to him.

But by then it was clear that the kids, especially Sandy, were already too attached.

And if they took Bob to the pound, he'd never find another home. People want a watchdog, a hunting dog. Nobody wants a dog that won't even go outside. Especially not one of this size. Because Bob was growing. It was clear he was getting big. Everybody had an opinion about what kind of dog he was, and although nobody knew for sure, Purcell felt certain he was at least half hound. He had that pretty red freckling, those long ears, and that kind of head. But he hung his head and walked sideways, getting behind the couch. He put his tail down between his legs. Bob looked ashamed, like he didn't have any pride.

—Lee Smith

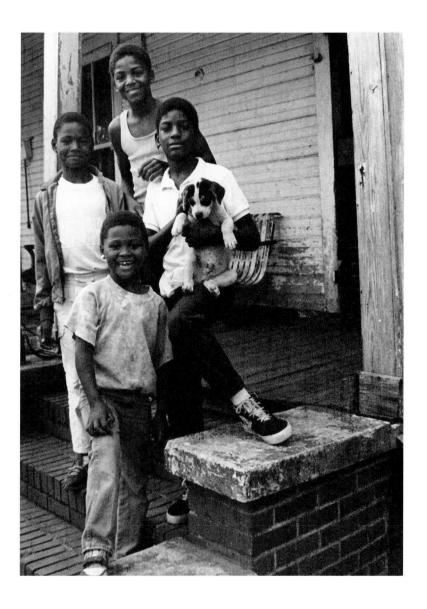

Nowhere else does screened porch wire

Gray the light so steadily, do moths

Circle bulbs at noon, pecan leaves wave

As in a paperweight's fluid. Here is

Childhood's landscape, glassed in a frame.

Caught in this jewel focus, the one

Bright place squeezes water from our eyes.

—*James Applewhite*

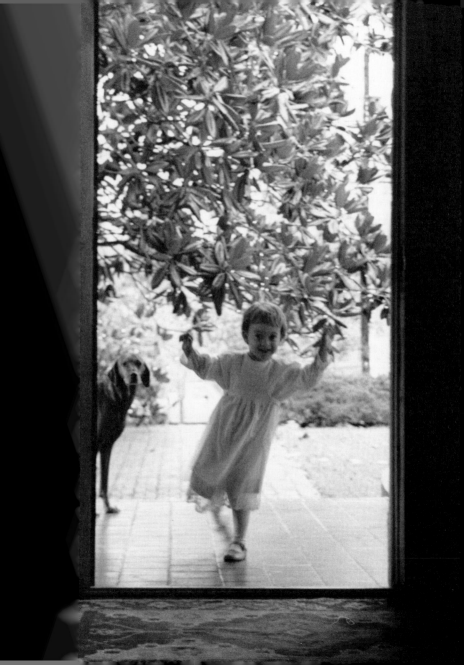

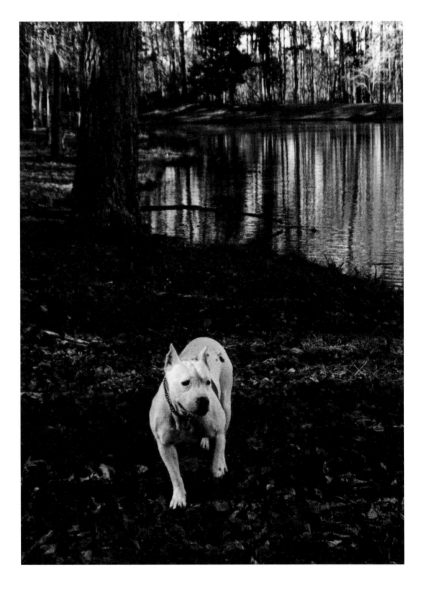

 . . . Does he thus stand on a final edge
Of the world? Sometimes he stands thus,
 and will not budge,

With a choking soft whimper, while monstrous
 blackness is whirled
Inside his head, and outside too, the world
Whirling in blind vertigo. But if your hand
Merely touches his head, old faith comes
 flooding back—and

The paw descends. His trust is infinite . . .

 —*Robert Penn Warren*

SARA LEE

I always thought that if she had a dog she'd name him Spot—without irony. If I had a dog, I'd name him Spot, with irony. But for all practical purposes nobody would know the difference.

—*Flannery O'Connor*

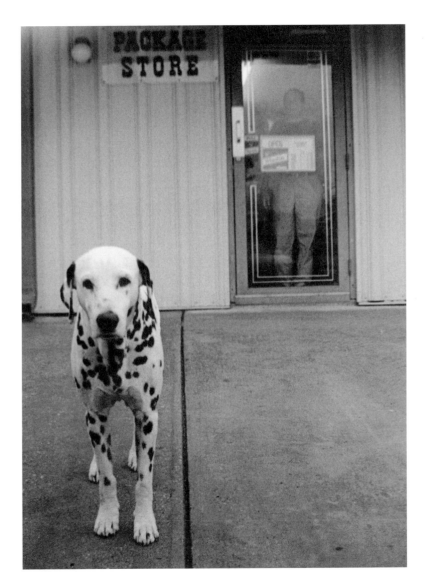

"**D**og is my copilot," Ben said, glancing in the rearview. Cliffie disapproved of dogs and blasphemy.

—*Mary Hood*

EARNEST, PRECIOUS, AND LAMBIE

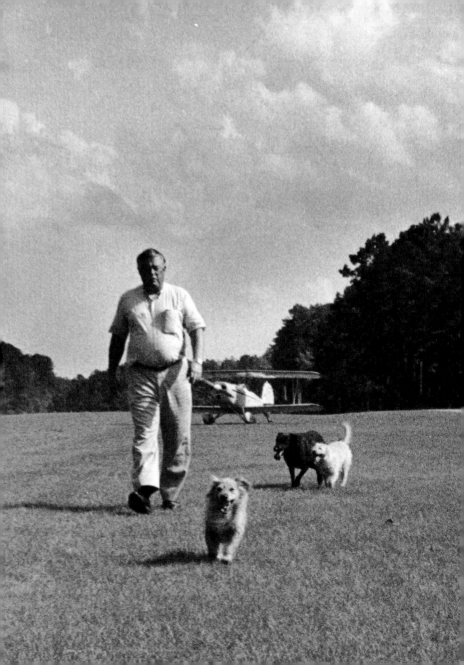

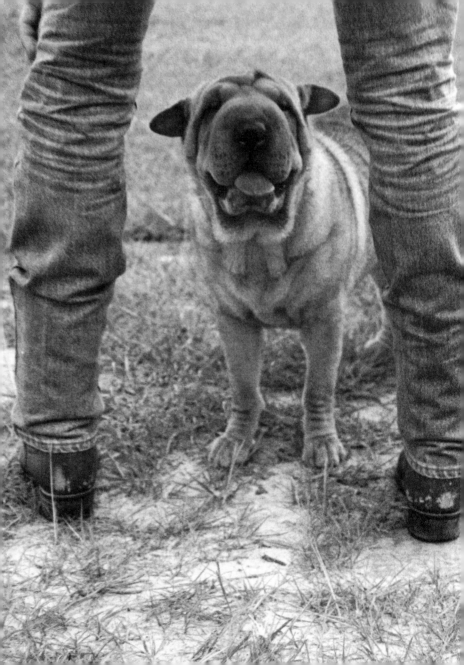

I've said it often, but it remains true:
The thing about a dog is, you can come
home at any hour, in any condition, and
the dog cares not. He, or she, is just
glad to see you.

—*Lewis Grizzard*

LITTLE BIT

The old man named his new companion Nipper—after the dog on the label of Jimmie Rodgers' records. It was in his mind to train the animal, but he immediately discovered that it needed very little encouragement. If he allowed it to lie on the foot of his cot, it remained quiet. If he set it outside, it began to bark. Meecham rewarded its efforts with bits of tinned mackerel, and noted with delight that when he teased the dog with a section of fish it would erupt into a fierce barking, its little black eyes bulging, ugly as something left on a beach by the tide.

—William Gay

BULLDOG CHEATHAM

He was lying on the back steps of Mattie Rigsbee's brick ranch one summer Saturday morning when she opened the door to throw out a pan of table scraps for the birds. She placed her foot on the step beside him. She was wearing the leather shoes she'd cut slits in for her corns. The dog didn't move. Holding the bowl, Mattie stepped on out into the yard and tried to see if it was a him or her so she could decide whether or not it *would* have been possible to keep it if she were younger and more able. If it insisted on staying she'd have to call the dogcatcher because she was too old to look after a dog—with everything else she had to do to keep up the house and yard. She was, after all, seventy-eight, lived alone, and was—as she kept having to explain—slowing down.

—*Clyde Edgerton*

SCRUFFY

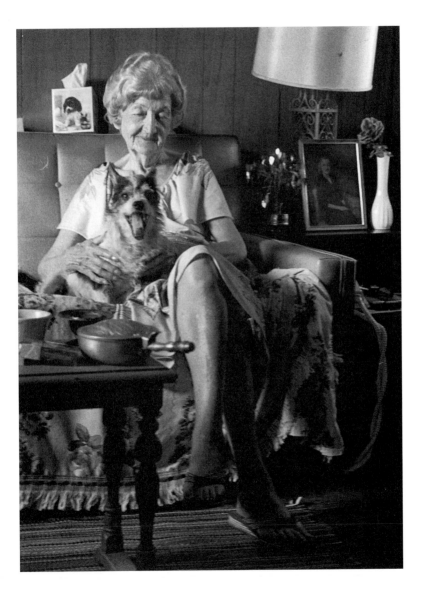

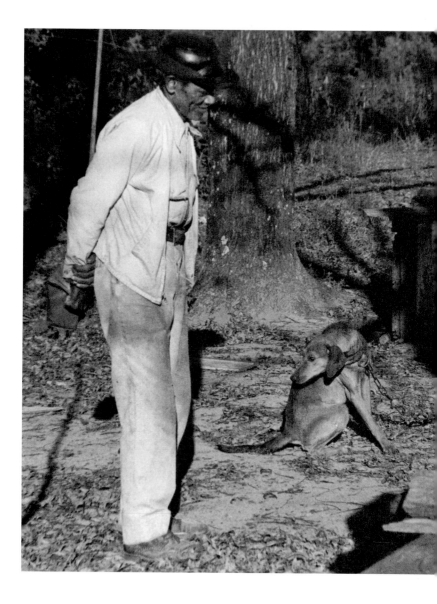

My loving and trusty friend, the defender of my children, the protector of my household in the dark and silent watches of the night. For thirteen years he has been both fond and faithful . . . the best judge of human nature I ever saw. He knew an honest man and a gentleman by instinct. . . . He had character and emotions.

—Bill Arp

M R . P A U L ' S H O U N D D O G

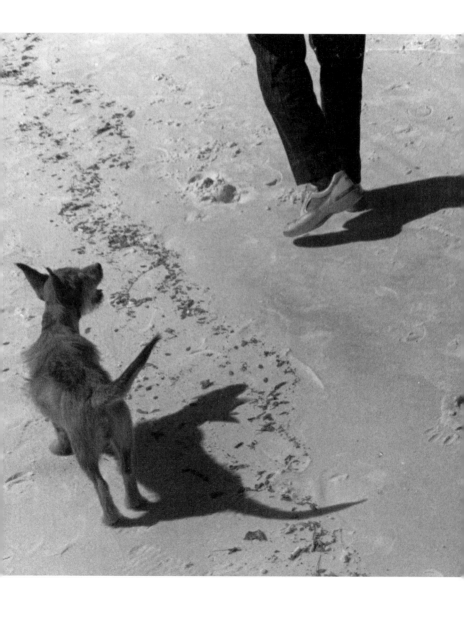

"Biters, barkers, deaf dogs, timid dogs, dogs that haven't been treated right, dogs that have learned bad habits, dogs that grew up in pet shops and don't trust human beings . . . I can handle all of those."

"Well, good," Macon said.

"Not that he would bite *me,* of course," the woman said. "He just fell in love with me, like I think I was telling you."

"I'm glad to hear it," Macon said.

"But I could train him in no time not to bite other people. You think it over and call me. Muriel, remember? Muriel Pritchett. Let me give you my card."

She handed him a salmon-pink business card that she seemed to have pulled out of nowhere. He had to fight his way around Edward to accept it. "I studied with a man who used to train attack dogs," she said. "This is not some amateur you're looking at."

—*Anne Tyler*

DESTIN BEACH DOG

So Miss Ella and Aunt Ella
and the white dog went for their
afternoon drive leaving the sweet
cool of the old garden to the
aromatic shrubs, the fireflies and
the spiders who made their webs
in the box-wood . . .

—Zelda Sayer Fitzgerald

CHARMIN AND GIDEON

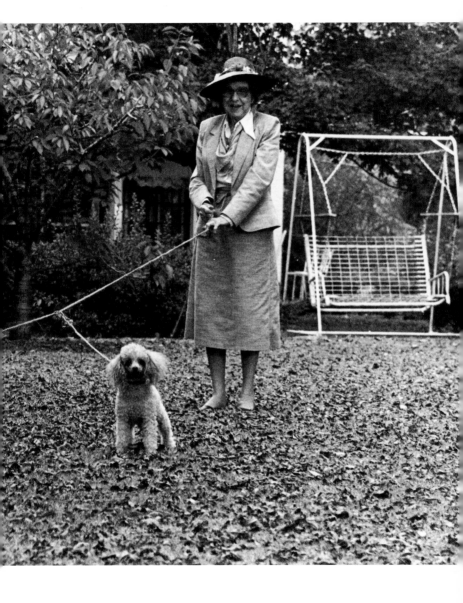

Woody would be out by the dog pen,

a good many yards on past the chickens.

We'd join him there, in a wide globe of

the rank clean odor of working dogs.

Mac would count the dozen or fifteen

smart-faced, wigglesome and ever-ready

hounds; and he'd name them over with no

hesitation (to my valuable instruction—

that so many of any one thing deserved

proper and characteristic names and got

them, even from these busy men).

—*Reynolds Price*

ROLAID'S PUPS

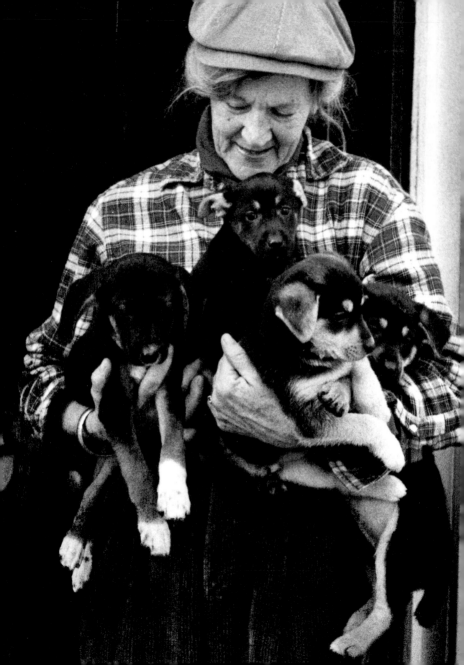

The puppy, almost shapeless, shivers

in my hands, threatens to slide out of

them onto the concrete. I press my cheek

against the lump of fur and let its warm,

faintly fecal odor slip into my memory.

I have smelled this smell before.

—*Michael Bishop*

The Ellafair puppies

It was around noon when I made my second trip to the well that day. The Carolina heat poured down on everything and there wasn't a breath of air stirring. It was quiet all over the hillside. It wasn't a day for visiting or trading gossip. The porches were empty. People who weren't at work had gone inside their houses out of the hot sun and the neighborhood dogs had crawled beneath the houses to lie panting in the dust.

—Pauli Murray

WILLIE'S FRIEND

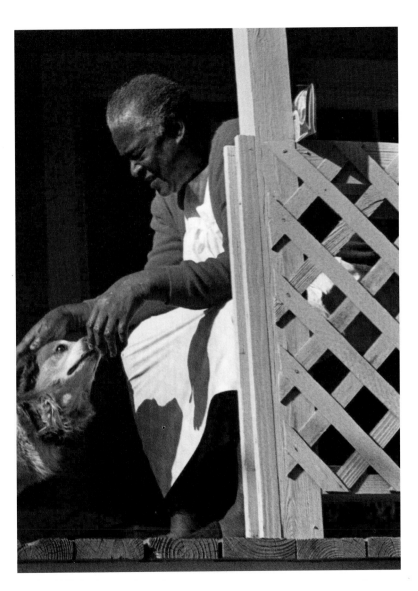

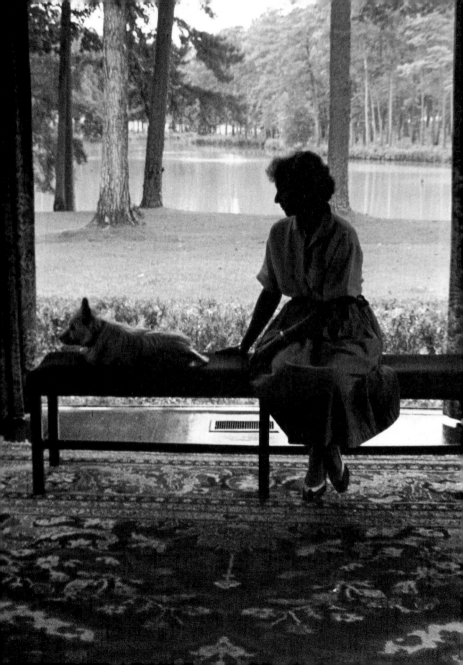

At my feet was a white dog whose name was Sam. I looked at the dog and at the house and at the red gown with little pearl-colored buttons I was wearing, and I knew that the gown had been made for me by my Grandma Hazelton and that the dog belonged to me. He went everywhere I went, and he always took precious care of me.

Precious. That was my mama's word for how it was between Sam and me . . .

—*Harry Crews*

BILLY BOB

I jump against the fence of our kennel and outbark dogs even larger than I am. The cold is invigorating. My flanks shudder with expectation, and I know that insomnia is a sickness that afflicts only introspective university instructors and failed astronaut candidates.

—*Michael Bishop*

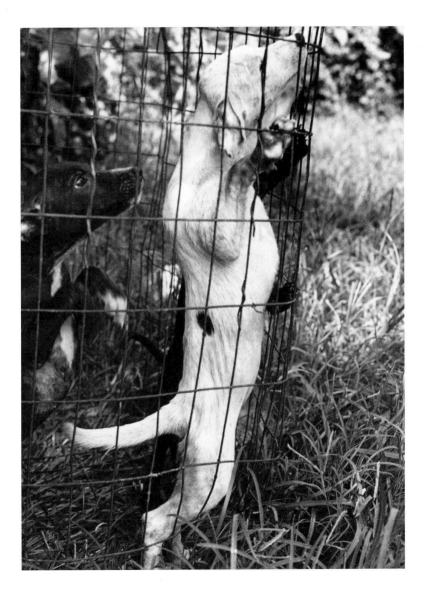

This is the beauty of being alone
toward the end of summer:
a dozen stray animals asleep on the porch
in the shade of my feet,
and the smell of leaves burning
in another neighborhood.

—*James Tate*

BEN AND BOOMER

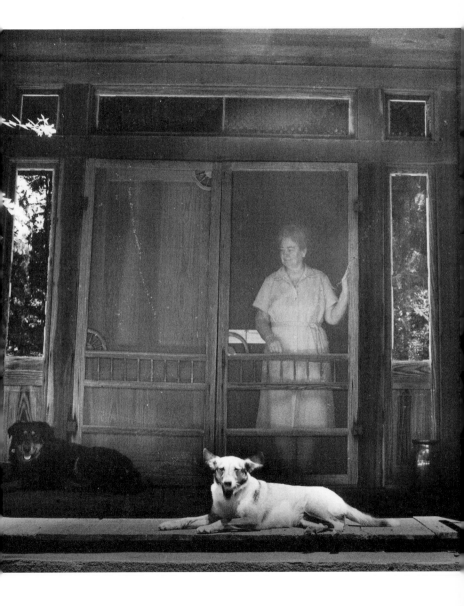

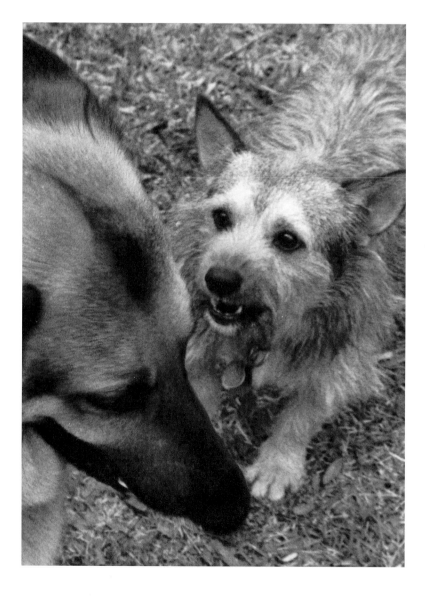

My daddy's dog, Nipper, was growling

low and making his chain clank in the yard.

He was a sullen dog trained to drink beer

and bite strangers. He'd been known to leap

from a speeding truck's window to chase

down and fight any hound he saw.

—*Mary Karr*

Sally and DoDah Davis

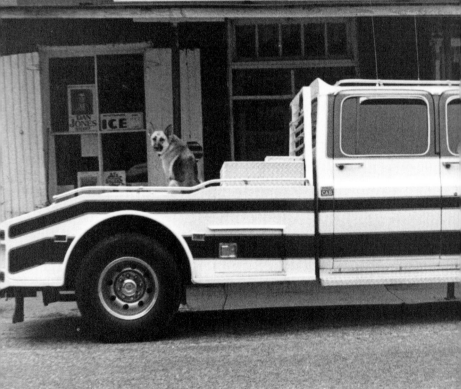

In front of the porch posts of the store
a man seated on a soda water case
turns around and spits and says
to everybody
in his new set of clothes
holding up his hands
as long as I live nobody
touches my dogs my friends

—*Frank Stanford*

HEY JUDE

He remembered one time him and Rabie was hunting quail over near Molton. They had 'em a hound dog that could find a covey quickern any fancy pointer going. He wasn't no good at bringing them back but he could find them every time and then set like a dead stump while you aimed at the birds.

—*Flannery O'Connor*

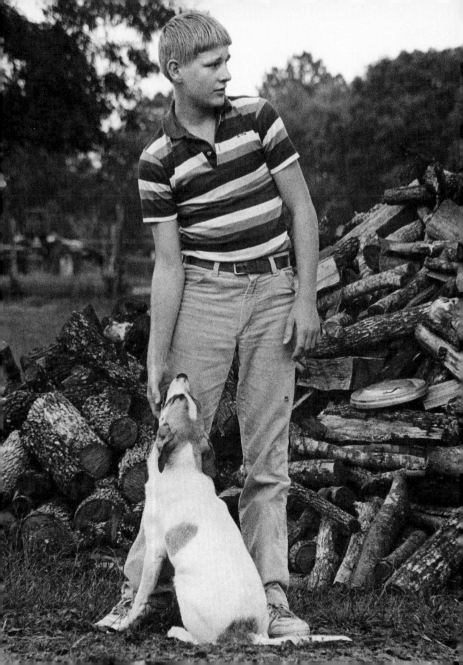

"Animals!" he said brightly. "Ever considered what they must think of us? I mean, here we come back from the grocery store with the most amazing haul—chicken, pork, half a cow. We leave at nine and we're back at ten, evidently having caught an entire herd of beasts. They must think we're the greatest hunters on earth!"

—*Anne Tyler*

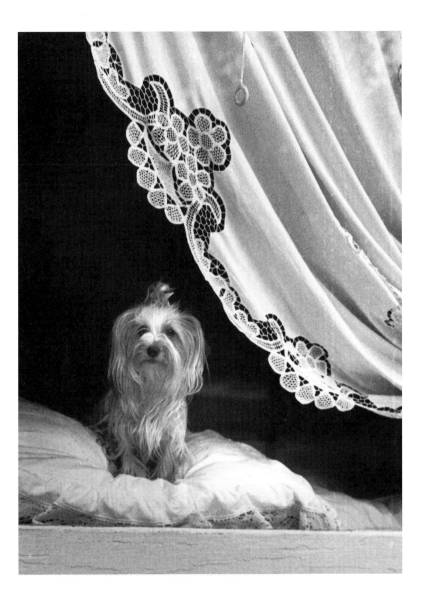

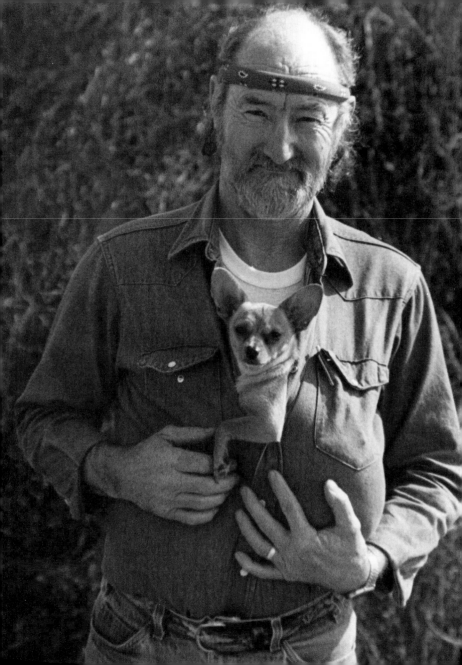

I took him to Ireland's when he was about six inches long . . . I had him buttoned up inside my shirt with just his little black head sticking out, and I'd go sneaking up behind girls, with a beer in my hand, rubbing his cold little nose on their bare arms to give them sort of a goose. He's been like one of my kids ever since.

—*Larry Brown*

DINK DINK

. . . though briars had scratched maps
across the back of my hands
and stumps were aimed like mortars
straight up for a last stand,

it was not my war.
The five warm lumps at my back
were quail minus their heads
the setter had swallowed intact,

spoils for having had the nose
that turned to steel before they rose.

—*D. C. Berry*

ABBY

I led a dog's life in that flat. Most all day I lay there in my corner watching the fat woman kill time. I slept sometimes and had pipe dreams about being out chasing cats into basements and growling at old ladies with black mittens, as a dog was intended to do. Then she would pounce upon me with a lot of drivelling poodle palaver and kiss me on the nose—but what could I do? A dog can't chew cloves.

O. Henry

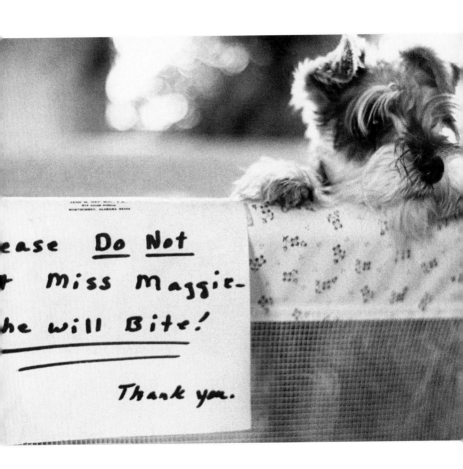

MISS MAGGIE

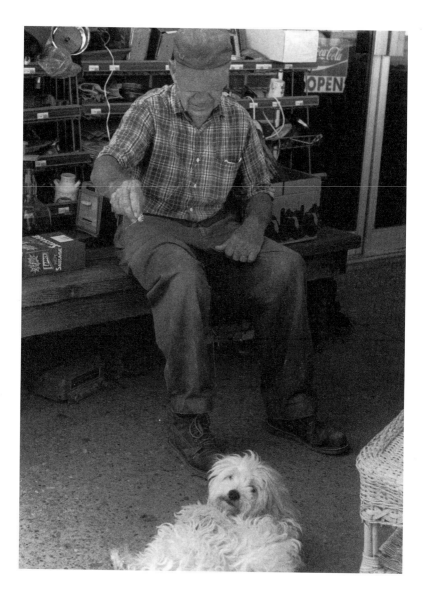

He's terrified of thunder and lightning, will crawl up in your lap and cry over it, but will fight and kill snakes and rats. He's an excellent mole dog. . . . We have a lot of fun with him and one of the things we do to him is pick up Pooch, our other dog, a white beagle, and hug him and push Sam back, and before long he'll perform these incredible leaps four feet off the ground. . . . It's really enlightening to watch it and wonder about the emotions of dogs. It's pure jealousy, and you wouldn't think a dog would know jealousy. It opens up other ramifications, like, do they know heartbreak? And loneliness? And angst? I think they do. I think they know fear and greed and love, impatience and uncertainty.

—Larry Brown

BUSTER

That puts me in mind of Buford Rhodes and his coonhounds. Buford was a good old boy anyway you want and kind of crazy about raising coonhounds and was an awful smart hand at it. Lived out there in Sudie's Cove in a tin-roof shack with his wife and six younguns and must have been a good dozen dogs. All kinds of dogs, Walkers and Blue Ticks and Redbones and lots of old hounds with the breeding mixed in like juices in soup. One of them named Raymond you couldn't never figure out, must have been a cross between a bloodhound and a Shetland pony. Kids rode that dog all day like a pony, he was that good-natured.

—Fred Chappell

DIGGER

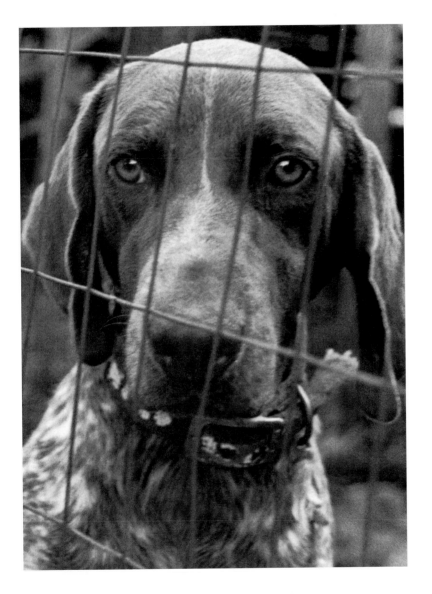

Then she saw what our black-and-white mixed terrier, Chipper, was doing. "And Chipper's just sitting there, chewing on the chair leg!" she said. Chipper looked up and gave us a smile that was sort of ingratiating, but not exactly. Some people have mean dogs, some people have pretty dogs, we had funny dogs.

Our dogs were greatly indulged, but they also put up with a lot, emotionally. They often walked around looking as if they were talking to themselves, probably because we talked to, and for, them too much.

—*Roy Blount, Jr.*

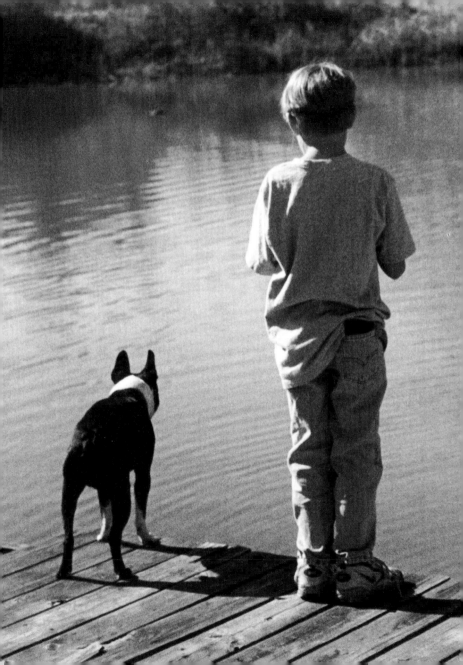

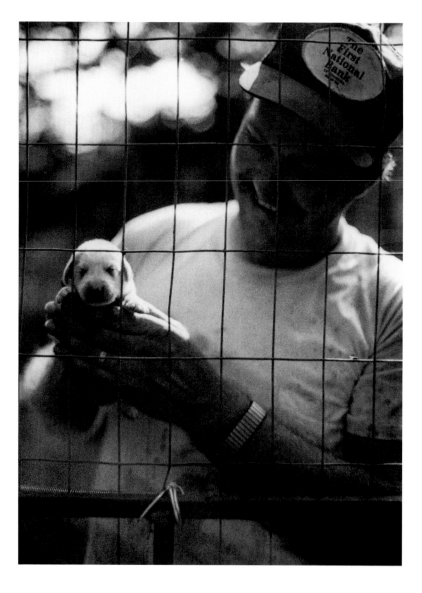

Another time I sold a puppy to the right people and bought it back and sold it to the wrong people, who got it stolen. The right people I *thought* the wrong people were kids in a garage band who wanted the dog to protect their equipment. When I got there to buy back the puppy, it was on the knee of one of the boys, watching cartoons with them. *I took the dog back*. Then I resold it to a family man who had children not yet rock 'n' roll age. He managed to let the dog be stolen, which the rock 'n' roll boys would never have done. And what would protect the boys' amps and drums and guitars now?

—Padgett Powell

Anyway, they had worried the dog might eat the baby when they brought him home, but it turned out the opposite; the dog loved the child. So much so that in the long run they trusted the dog to watch the baby. They might go out and work their land or even leave the place altogether for a short spell, knowing the dog would see everything was all right. This all happened at that same place at Keyhole Lake, and one time, so the story went, little Peter Jackson, only two or three years old, let himself out of the house somehow and went wandering all the way down to the shore. This old dog went right along with him, saw he didn't drown himself or get any other kind of hurt, and in the end when the child was tired, the dog brought him on back home.

—Madison Smartt Bell

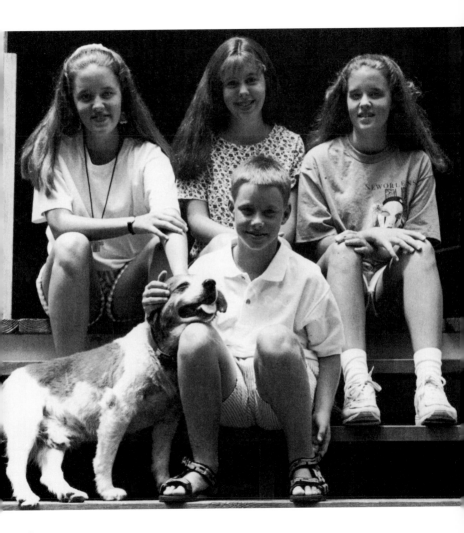

JACOB

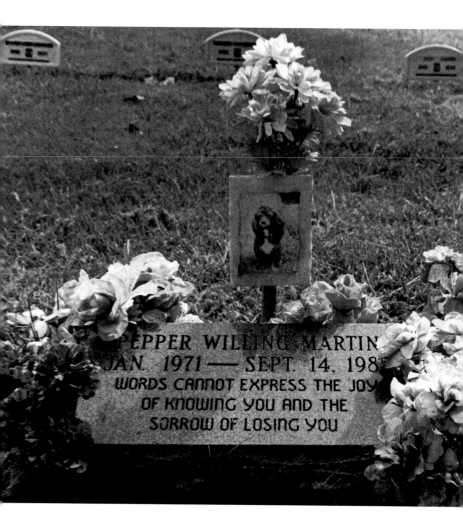

PEPPER WILLING MARTIN

JAN. 1971 — SEPT. 14. 198

WORDS CANNOT EXPRESS THE JOY
OF KNOWING YOU AND THE
SORROW OF LOSING YOU

PEPPER WILLING MARTIN

"Buddy dear," she writes in her

wild hard-to-read script, "yesterday

Jim Macy's horse kicked Queenie bad.

Be thankful she didn't feel much.

I wrapped her in a Fine Linen sheet

and rode her in the buggy down to

Simpson's pasture where she can

be with all her Bones . . ."

—*Truman Capote*

A dog leaped up from where he'd lain like a stone and began barking for today as if he meant never to stop.

—*Eudora Welty*

We call him George

Maestro Handel. He thinks

he's a conductor, wags

his tail constantly as

if every direction he turns

he's got an orchestra

back there.

 —D. C. Berry

The dog, Shin, rode between them atop a pile of bedclothes that wouldn't fit in the trunk. She was a medium-sized dog, not young but alert, her hindquarters on the package tray, her front legs stretched out, her chin down, her ears up. She widened her grin into a sour yawn, but her eyes never left off for a moment searching the center line that came at them out of the dark.

—Mary Hood

T.J.

All those animals lived in the lap of luxury. We had a married couple— James and Louisa—who lived in a house in the yard. James tended the horses and Louisa tended the dogs and cooked for them in a big black pot. That pot held ground corn and what Dad called "crackling"— bones and cured parts of various animals. . . . So there was a circle of dogs around Louisa when she dipped from the pot.

—Emily Whaley

RONNIE'S PUPPIES

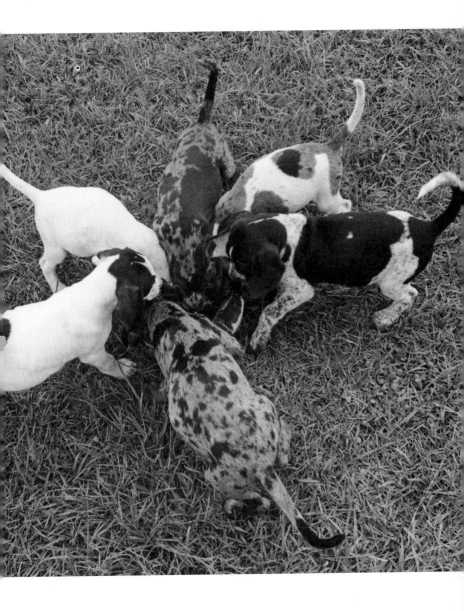

I came across a photograph of him not long ago, his black face with the long snout sniffing at something in the air, his tail straight and pointing, his eyes flashing in some momentary excitement. Looking at a faded photograph taken more than forty years before, even as a grown man, I would admit I still missed him.

—*Willie Morris*

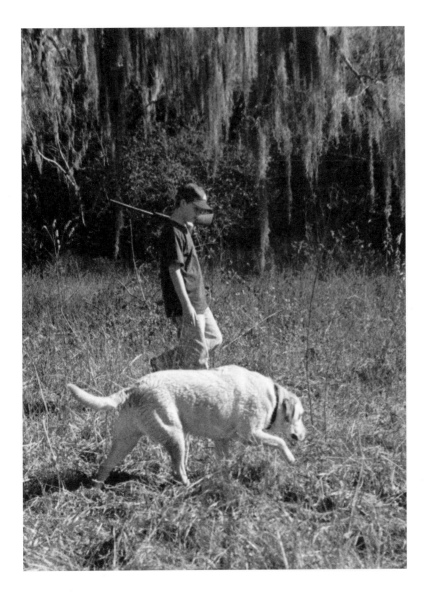

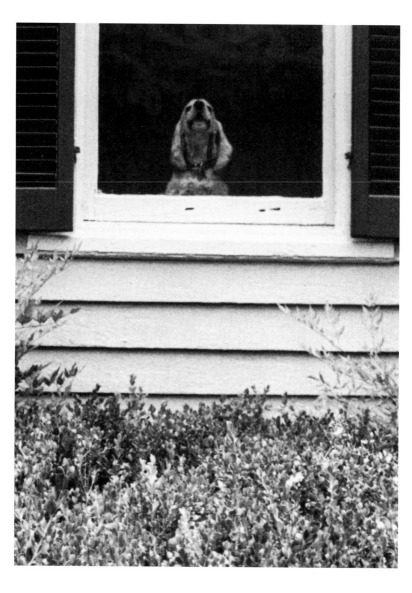

"**W**ho's that?" I asked.

"A pretty little dog," Leah said.

"Not just any pretty little dog."

"*That's* the Great Dog Chippie," Leah cried out. "But Daddy, she's so small and cute. I thought Chippie must be the size of a St. Bernard."

"No," I said. "She slept with me, on my pillow, every night. My mother would come in, kick her out, and banish her to the downstairs, but Chippie'd always be there when I woke up in the morning."

—*Pat Conroy*

Sunny

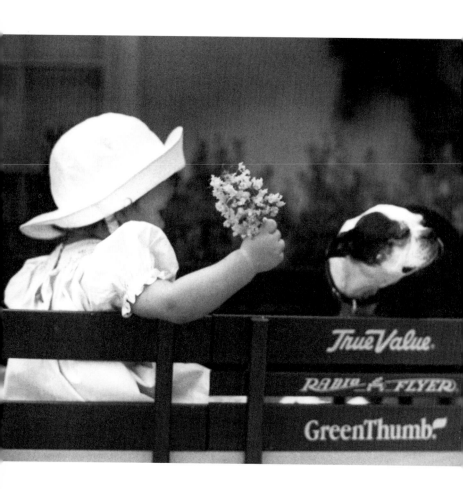

BABY DOLL

His bark was short and mocking. Sometimes she could hear a faint murmur as Ethan bent to the dog. Was he talking to Bean? Or was it the low, chiding music children make for animals? She listened with a kind of hunger in her stillness, till she was dizzy with being in the body of the dog, running back and forth beneath the voice of the child.

—*Helen Norris*

We reached the town in Alabama toward the middle of the afternoon and we spent the night in an old clapboard hotel on the courthouse square. After dinner that night, the two men sat in the lobby and talked to other men who were staying there in the hotel. I found myself a place near the stove and sat there with my feet on the fender, sometimes dozing off. But even when I was half asleep I was still listening to see whether, in their talk, either Mr. Lowder or my uncle would make any reference to our adventure that morning. Neither did. Instead, as the evening wore on and they got separated and were sitting with two different groups of men, I heard them both repeating the very stories they had told in the car before we crossed the Tennessee River—stories about bird hunting and field trials and about my uncle's three-hour breakfast in the old house with the neoclassic portico.

—Peter Taylor

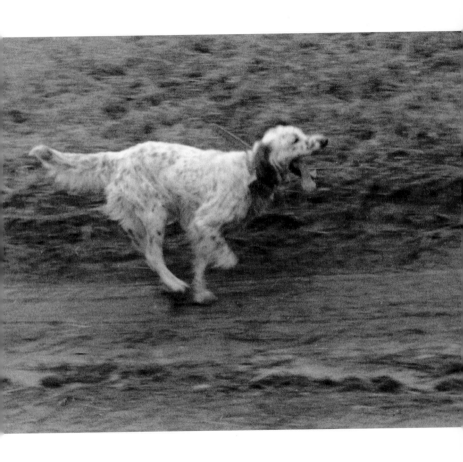

CANDY

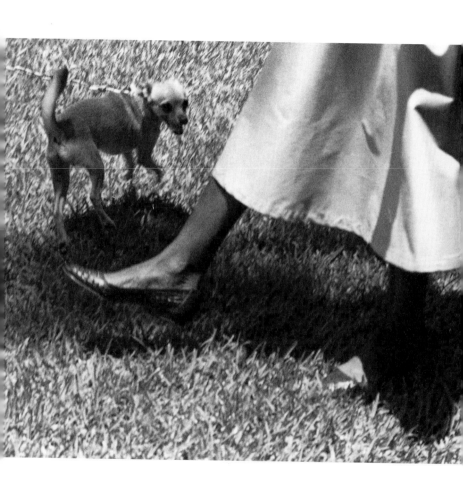

L E O L A

The watch was upgraded to a warning, the wind began to scream, and we could see the tops of the long-leafed pine trees doing a mad dance against the black sky. The dog and I plastered ourselves like cardboard cutouts up against a bearing wall in the middle of the house. But my mother, who is not afraid of anything, tottered out to her little bed on the screen porch as usual with her cup of Ovaltine and *Young Men in Spats,* by P. G. Wodehouse. "I'll come in if it gets too bad," she said.

—*Bailey White*

Each boy carried a dried slippery elm limb about three feet long. They were playing stick ball, swinging and hacking at a dried sycamore seed case, trying to knock it through a hoop they had woven from broom sedge. They were a team, battling an imaginary team they pretended was defending the goal. A tan and white bench-legged feist named Cito, the Choctaw word for big, ran with them, barking in unison with their swings. They screeched and complained good-naturedly when they stumbled or tripped over the frolicking dog, sometimes falling over him on purpose, making him part of the game. He soon caught the seed case with his teeth, breaking it into bits, the fragile, tissue-like pieces scattering with the wind.

—*Will D. Campbell*

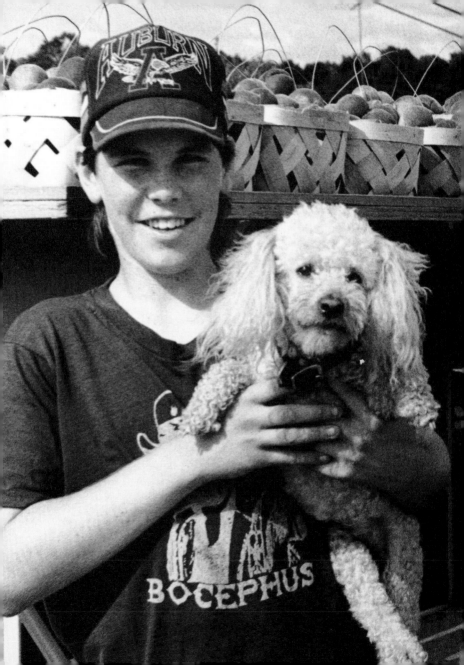

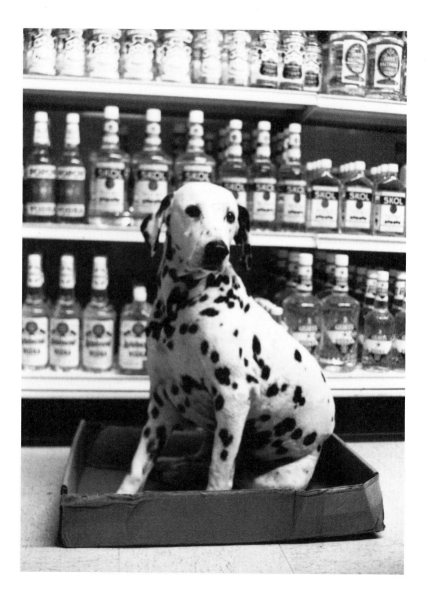

He whistled for Oliver, a very old and decrepit Dalmatian, the same dog who had lived in the dorm with him at Yale. Last night Robinson had forgotten to let him in, and the poor dog had slept on a patch of cane shoots. Robinson remembered his dog at five in the morning, and went out in the backyard looking for him. Robinson heard all quiet except for the cracking sounds of growth in the hedge, which was thirty feet high. He heard whimpering sounds above him. The cane had grown under the dog and lifted him up eight feet in the air. The dog was looking down at him. Robinson met the dog's look. We love each other, Robinson said. Don't be afraid. He got his ladder and lifted Oliver down from the cane tops.

Love slays fear, said Robinson.

—Barry Hannah

R . J .

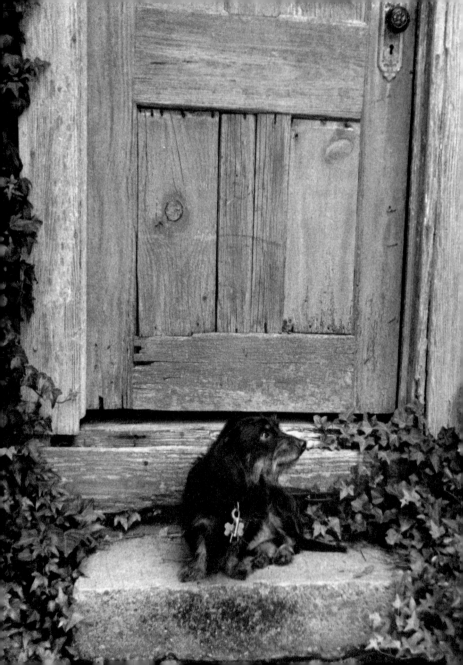

My dog yelps and darts

from one to another. Her mouth full of words,

she wags her tail and drops them at my feet:

wind, star, pomegranate, edge, stone.

Each feels damp, rose-petal cool, a wafer,

delicate as a blessing, to take and eat.

—*Sue Lile Inman*

The man walks with difficulty. . . .
The dog is young and steps delicately
around the pavement and the grass.
The man has dignity. He does not
want your pity. His beloved dog
prances back and forth around him,
helping him scent the beer cans.
This is a college town and the beer
cans lie everywhere. I believe he
might get a penny apiece for them
at the recycling plant.

—Barry Hannah

SCHANTZEE

86

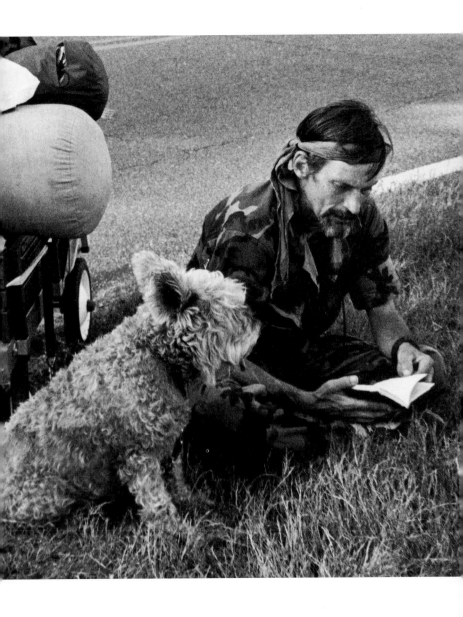

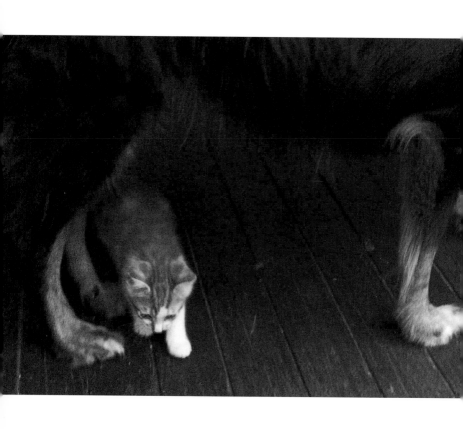

ELLA AND KITTEN

For a while after Bobby Lee moved into the house, Rudy was jealous, claimed priority, and used his claws and body to physically shoulder Bobby Lee aside to keep him from getting near me. He thought Bobby Lee was his dog, not mine. Bobby Lee quickly memorized the location of each object in the house. As soon as he gained confidence in his surroundings, he gently but firmly let Rudy know they were equals, not master and slave. He still allows Rudy to boss him around occasionally, inside. But outside he is my dog and devoted worker from his gifted nose to the tip of his tail. Rudy, after all these months, still sits on the back porch and grumbles and whines when I hook Bobby Lee to his lead; he is one stubborn cat.

— *Virginia Lanier*

One young lady has managed to escape the fray for a few moments of solitary introspection on what it means to be a Southern belle. She is trying to concentrate on the dazzle and glamour of the official image . . .

—*Florence King*

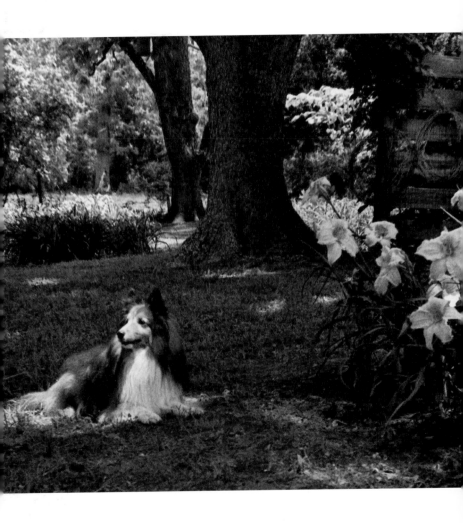

EDWARD

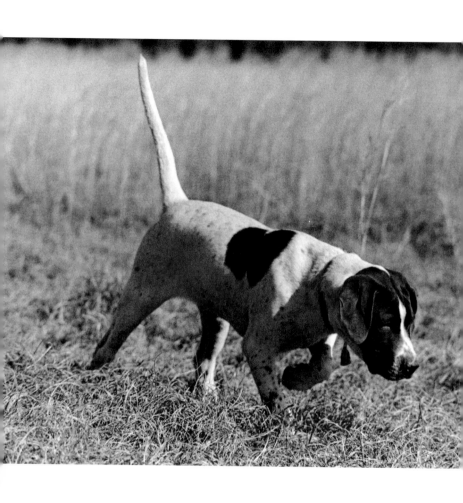

R A Z M A T A Z

The dogs were already out of sight but I could see the sedge grass ahead moving and I knew they'd be making for the same thing that took my eye: a spearhead of thicket that ran far out into this open field. We came up over a little rise. There they were. Bob on a point and Judy, the staunch little devil, backing him, not fifty feet from the thicket. I saw it was going to be tough shooting. No way to tell whether the birds were between the dog and the thicket or in the thicket itself. Then I saw that the cover was more open along the side of the thicket and I thought that that was the way they'd go if they were in the thicket. But Joe had already broken away to the left. He got too far to the side. The birds flushed to the right and left him standing, flat-footed, without a shot.

He looked sort of foolish and grinned.

I thought I wouldn't say anything and then found myself speaking:

"Trouble with you, you try to outthink the dog."

—Caroline Gordon

Dogs are incapable of blushing, a fact which has given rise to the suggestion that they are incapable of shame. Even if dogs could blush this would pass unnoticed on a black dog. Man is the Only Animal that Blushes. Or needs to.

—*Mark Twain*

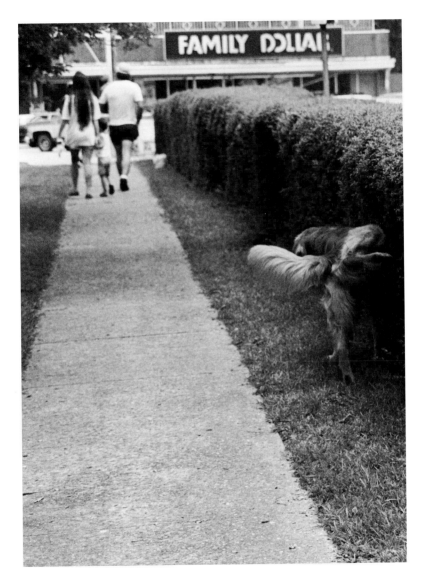

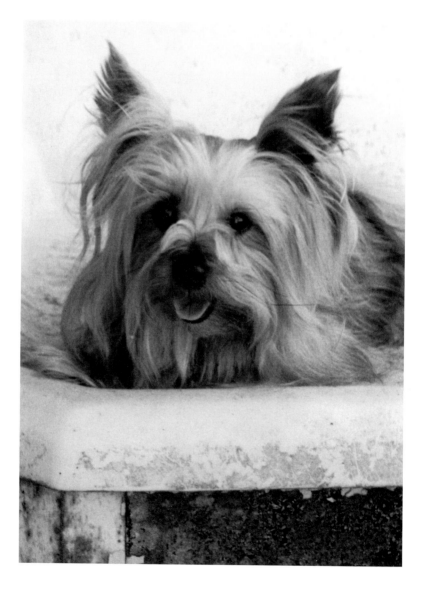

They put him in the little sink in the galley with a towel laid in it, and he was as snug as he was in his cardboard box, and the lapping of the waves and the rolling sea lulled him to sleep.

—Winston Groom

HANDSOME HORNY HARRY

What college football is all about is bragging rights.

—Lewis Grizzard

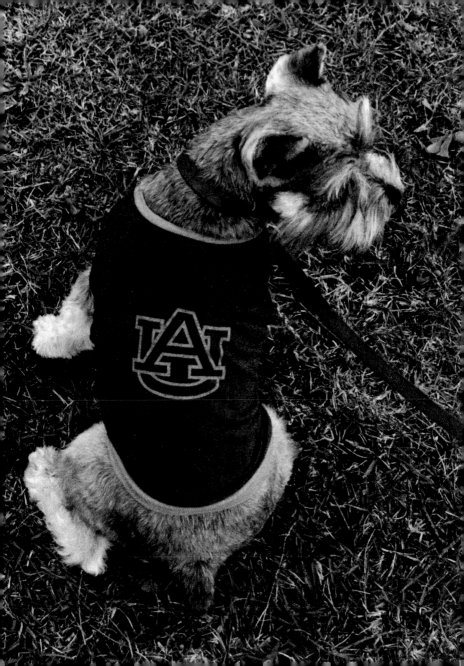

"**M**r. Green Bagett had a dog that ate mussels. My grandmother told me all about it. He would carry them up to the road in his mouth and when the sun made them open he would suck out the insides." Shelby leaned on his hoe, making a loud sucking noise. "He was a dog named Harry after Mr. Bagett's dentist and he would eat mussels all day long if nobody stopped him."

—*Ellen Gilchrist*

LADY

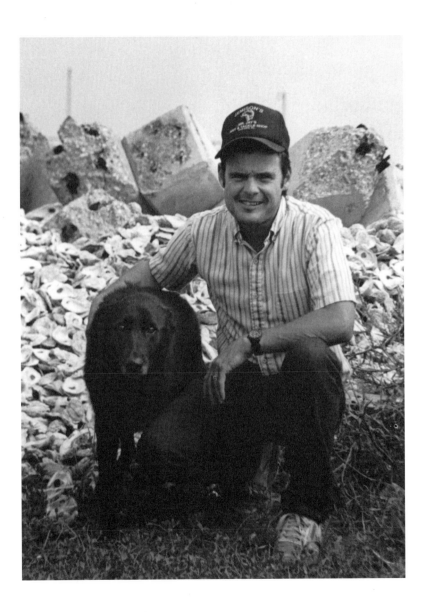

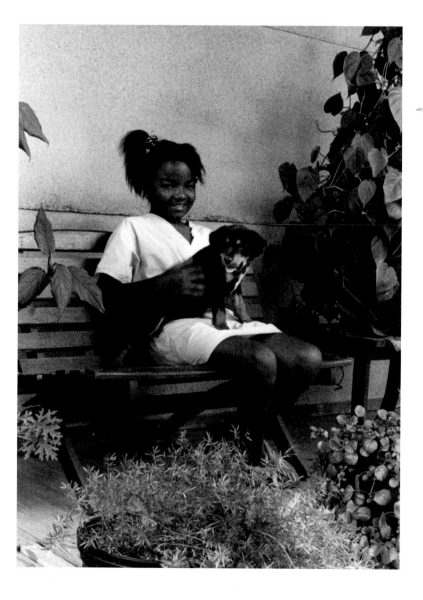

Elvie came with the speckled puppy carried high to her cheek, his rump filling the cup of one careful hand, and with a sigh she gave him up, sank him into Granny's lap. "He'll run anything with fur on it. He'll retrieve anything with feathers on it," she said in the gruff voice of Uncle Dolphus. The puppy yawned into Granny's face. In the open pan of his muzzle a good-sized acorn would have fitted closely. "He'll do it all."

—*Eudora Welty*

I obey, and am free-falling slowly

Through the thought-out leaves of the wood
Into the minds of animals.
I am there in the shining of water
Like dark, like light, out of Heaven.

I am there like the dead, or the beast
Itself, which thinks of a poem—
Green, plausible, living, and holy—
And cannot speak, but hears,
Called forth from the waiting of things.

—*James Dickey*

COOKIE SHORTBREAD

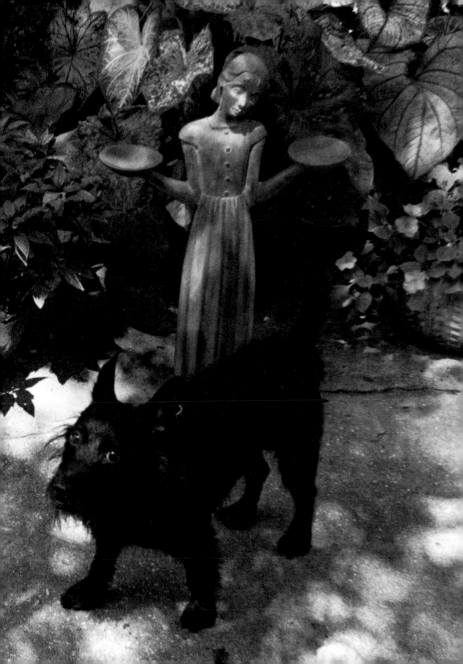

Once we made it out of the house, Uncle Zeno and I left in a hurry, pausing only long enough to scrape the ice off the windshield. If Uncle Al and Uncle Coran heard the sound of the truck starting in the yard, they did not dash barefoot out of their houses to see where we were going. And if our flight woke any of the hounds and pointers and assorted feists that divided their time and allegiances between our three houses, they did not crawl from out of their beds beneath the porches to investigate. We escaped cleanly, down the single block of Depot Street to the state highway.

—*Tony Earley*

MIKE AND MACK

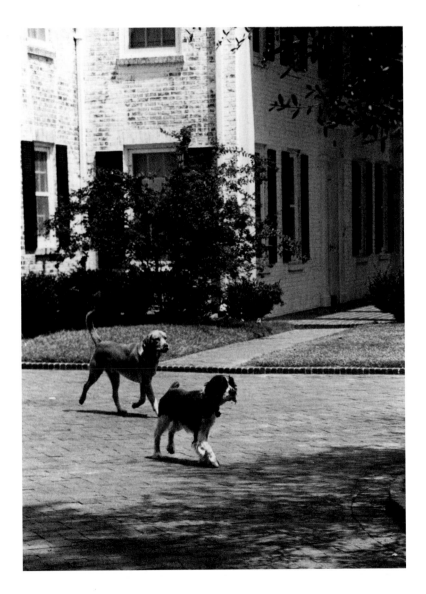

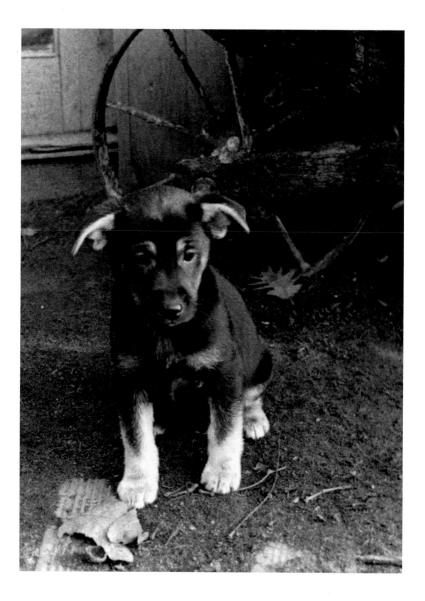

"Them dogs yonder can't smell out a straight track because they don't hate that fox. A good fox- or coon- or possum-dog is a good dog because he hates a fox or a coon or a possum, not because he's got a extra good nose. It ain't his nose that leads him; it's his hating. And that's why when I see which-a-way that fellow's riding, I'll tell you which-a-way that fox has run."

—*William Faulkner*

And back then they had this wild dog—they thought for a long time it was a cooter, or some even said a bear—but it turned out to be a wild dog, who used to kill calves. So one day . . . I looked up and there was the dog—that close to the house! It scared me half to death. I just froze. I went tight all over and would have screamed, but I couldn't. I remembered what they said about not getting nervous around animals because it only frightens them, so I didn't say anything and didn't move, I just watched. And after a while, just at the top of the hill where the earth had been busted open to get at the sand, the dog lay down and put its head on its paws—it must have been part bulldog—and watched me. I felt this peaceful feeling—extremely peaceful. It stayed there about an hour and then it went away and I went away. So I didn't mention it. I began to doubt if it had really seen me, because I heard somewhere that dogs' vision is not like humans', but I guessed it knew in its way that I was there. And the next time I went, it came again. I think this went on for about a week, and once I thought I would go close enough to pat its head. I had got so it was the last thing I'd ever be scared of, but when it had watched me climb to within just about from here to the end of the pier away from it, it drew back and got up and backed off. I kept on toward it, and it kept on drawing back and it looked at me—well, in a personal sort of way.

—Elizabeth Spencer

Benji

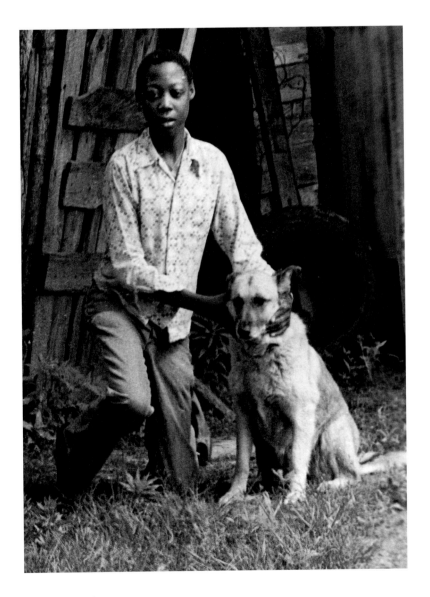

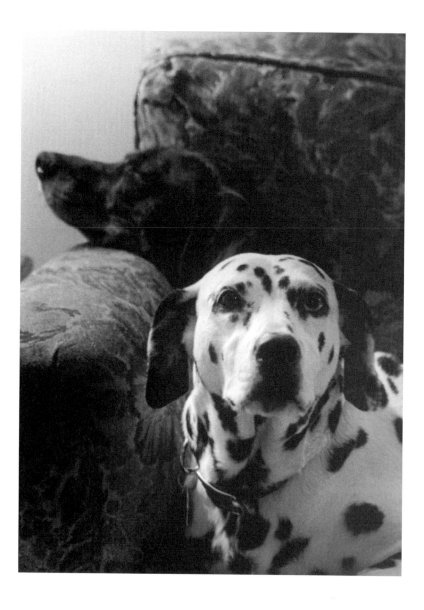

My dog is very polite . . . I begged him
and begged him to jump up in bed with me—
such a short little hop—but he just stood on
the floor and gazed at me down that long,
dignified nose of his. He has been trained not
to get on the furniture. I ended up dragging
my sheet and pillow down on his dog bed
and curling up with him there, but he woke
up and gave me a long look, then tiptoed
on his prissy little feet to the corner, where
he settled down with a sigh to sleep on the
cold, bare floor.

<div align="right">

—*Bailey White*

</div>

Lucy and Sam

Barbara heads out through the field. From the edge of the woods, she looks out over the valley at the mist rising. In the two years Barbara and Ruth have lived here, it has become so familiar that Barbara can close her eyes and see clearly any place on the farm—the paths, the stand of willows by the runoff stream that courses down the hill to feed the creek. But sometimes it suddenly all seems strange, like something she has never seen before. Today she has one of those sensations, as she watches Allison down by the house playing with the dog, teaching him to fetch a stick. It is the kind of thing Allison has always done. She is always toying with something, prodding and experimenting. Yet in this light, with this particular dog, with his frayed bandage, and that particular stick and the wet grass that needs mowing—it is something Barbara has never seen before in her life.

—*Bobbie Ann Mason*

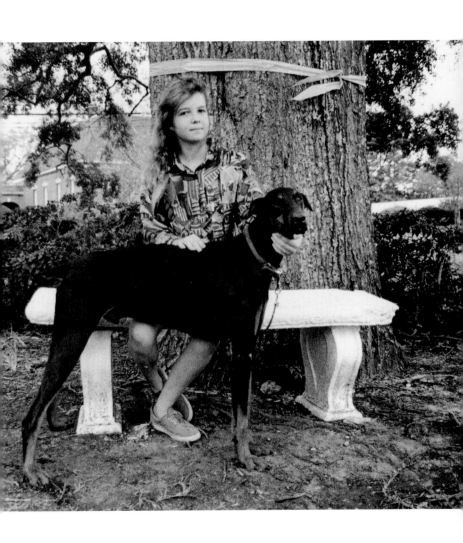

PORTIA'S PAL

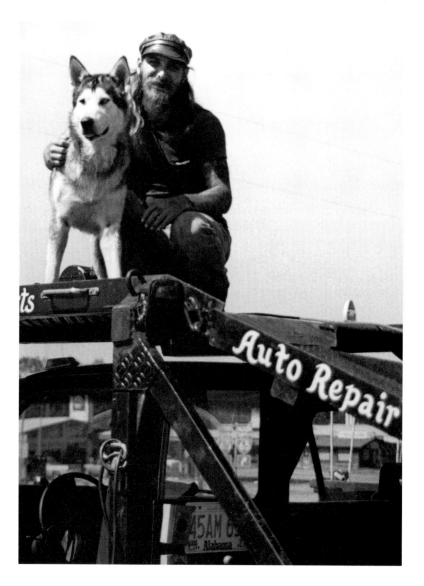

I had but one fear here: a dog. He was owned by the boss of the brickyard and he haunted the clay aisles, snapping, growling. The dog had been wounded many times, for the black workers were always hurling bricks at it. Whenever I saw the animal, I would take a brick from my load and toss it at him; he would slink away, only to appear again, showing his teeth. Several of the Negroes had been bitten and had been ill; the boss had been asked to leash the dog, but he had refused. One afternoon I was wheeling my barrow toward the pond when something sharp sank into my thigh. I whirled; the dog crouched a few feet away, snarling. I had been bitten. I drove the dog away and opened my trousers; teeth marks showed deep and red.

—*Richard Wright*

BEN

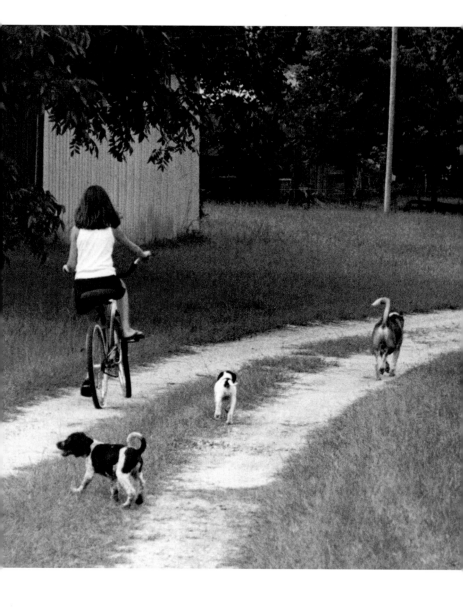

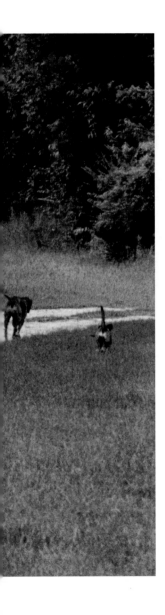

Being the only girl in the family, of course she must wash the dishes, which she did in intervals between frolics with the dogs. She even gave Jake, the puppy, a swim in the dishpan by holding him suspended above the water that reeked of 'pot likker'—just high enough so that his feet would be immersed. The deluded puppy swam and swam without ever crossing the pan, much to his annoyance. Hearing Grandma she hurriedly dropped him on the floor, which he tracked-up with feet wet with dishwater.

—*Zora Neale Hurston*

MEGHAN'S DOGS

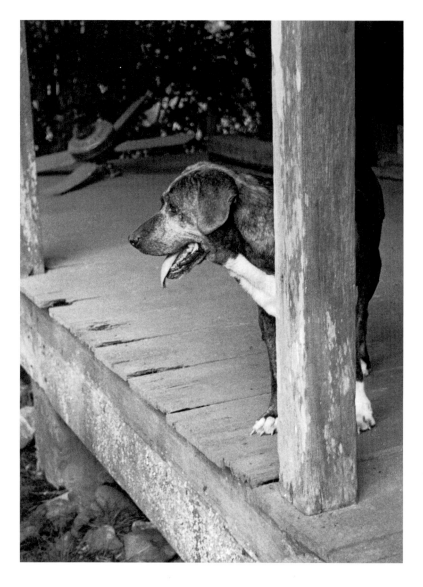

"Don't be ashamed of him, Lonnie, if he don't show signs of turning out to be a bird dog or a foxhound. Everybody needs a hound around the house that can go out and catch pigs and rabbits when you are in a hurry for them. A ketch hound is a mighty respectable animal. I've known the time when I was mighty proud to own one."

—*Erskine Caldwell*

BOOTS

It's my habit to drink coffee in the morning in the garden. Both of us love doing this. I might wander around checking on plants here and there . . . Rosie, in the meantime, is easing through a border. She's surefooted like Junior and never disturbs a single plant as she prowls. Or she might, with absolute delight, run up to a late-sleeping cat and chase it up a wall. When all that is attended to, she sits on one hip on the brick paving. She sits in the strategic middle, which allows her to see both ends of the garden, and she keeps an eye out for the slightest movement of the shrubs. Her ears are cocked, her eyes and body alert, and she is listening to sounds near and far and enjoying the breezes. Or she lies on the hot rocks in the middle of the day to treat her arthritis. I know dogs can be trouble, and yes, Rosie is sweetmeat for fleas. I can't leave her, though. Not even for a week. She wouldn't eat. I can't leave her.

—*Emily Whaley*

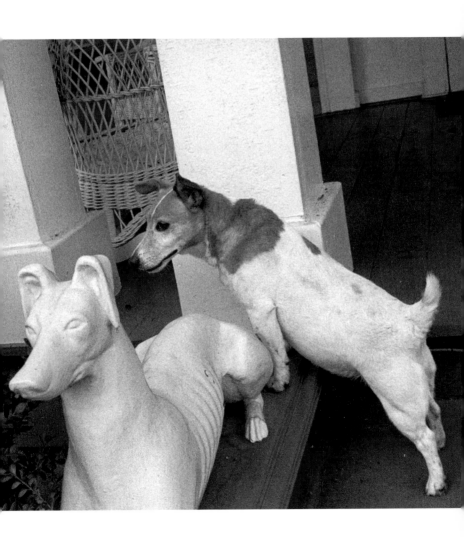

Lovy

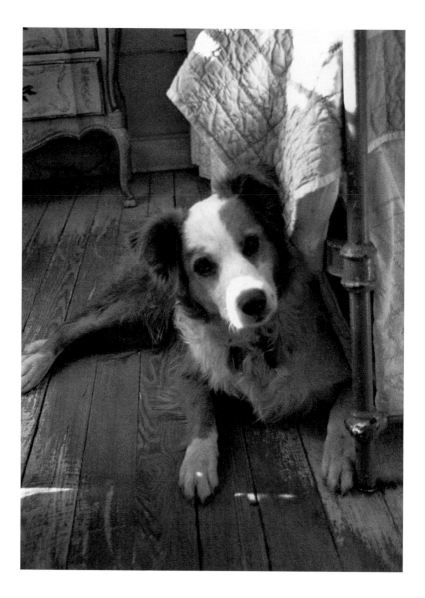

Credits

■ ■ ■